THE DIGITAL SOLUTION

A Plan For
Collecting and Distributing
Streaming Music Royalties

David M. Ross

DRoss@BossRoss.com

Copyright © 2014 BossRoss Media

Second Edition ©2015 BossRoss Media

All rights reserved.

ISBN-13: 978-1502745033

ISBN-10: 1502745038

David M. Ross

LONG LIVE
THE CREATORS…

MUSIC IS
THE FIFTH ELEMENT

-CONTENTS-

1	A DIGITAL MANIFESTO	6
2	HERE IN THE REAL WORLD	9
3	THE NAPSTER CHAPSTER	12
4	TOLL BOOTH AHEAD	18
5	COLLECTING THE FEE	23
6	CREATORS BENEFIT SOCIETY	27
7	DISTRIBUTING THE FUND	31
8	A BLANKET AND A LIST	36
9	FOCUS ON THE VISION	40
10	IMPLEMENTATION STRATEGY	42
11	IT'S NOT ABOUT RECORD LABELS	47
12	FREQUENTLY ASKED QUESTIONS	50

ACKNOWLEDGMENTS

For owners of intellectual property these are uncertain times. The music marketplace is transitioning rapidly, but royalty collection seems stuck in the past.

Songwriters, publishers, record labels, artists and other members of the creative community are caught like deer in the headlights. Everyone knows a train is coming, but can't seem to evolve their current business models in a way that will move them off the tracks. Physical product generated dollars and digital downloads reaped dimes, but streaming, the newest and soon to be largest distribution format, produces only fractions of a penny. Not a welcome trend.

The marketplace is beginning to experiment by bundling music with mobile phone services and Amazon Prime. This is a step in the right direction, but lacking in scale. *Pay On The Way Into The Store,* a term you will hear often in the following pages, may be the gateway to a plan that can benefit all stakeholders and earn support from *all* sides of the negotiation table.

If these concerns are important to you, then you are this book's target audience. But before we delve into its chapters please allow me to acknowledge some of the people who have been essential to its development.

A large number of people have helped tweak, refine, question and ultimately strengthen *The Digital Solution* at various times over the past decade. They perhaps will never realize how grateful I am that they took time to meet with me, encourage and/or respond to the ideas. **Michael Huppe,** Pres./CEO SoundExchange; **Vincent Candilora,** Exec. VP Licensing, ASCAP; **Jody Williams,** VP Writer/Publisher Relations BMI and **Richard Conlon,** former BMI Sr. VP Corporate Strategy/New Media; **Gary Overton,** former Chairman/CEO Sony Music Nashville; **John Esposito,** Pres./CEO Warner Music Nashville; **Pat Collins,** Pres./COO SESAC; **Steve Bogard,** Director The Copyright Forum; and **John Marks,** Sr. Dir. Country Programming Sirius/XM Nashville.

Special thanks goes to **Jeff Green,** Owner, Stone Door Media Lab for his incredibly astute assistance in the early stages of creating this manuscript. His enthusiasm and attention to detail were key in moving the project along. **Jim Griffin,** who consented to be interviewed in this book also had a key role. Griffin's legendary past research and role as a major rights player in the digital era set the stage for some of the ideas in this book and his razor sharp grasp of digital concepts helped give focus where others saw only blur.

Also thanks to the numerous friends whose attention and approval kept me moving forward. **Jay Frank,** CEO DigSin Records; **David Gales,** Managing Partner The Gales Network; **Frank Bumstead** and **Chuck Flood,** Flood, Bumstead, McCready & McCarthy; **Woody Bomar,** Owner Green Hills Music; and **Skip Bishop,** President, HitShop Records. And last, but not least, thanks to **Tim** "digital lightning' **Gerst** and designers **Michael Adcock** and **Kelsey Grady** who produced this book's cover art.

1. A DIGITAL MANIFESTO

My journey down the manifesto pathway started sometime in early 2003. The music world was still reeling from the rise and fall of Napster (RIP, June 1999—July 2001) and few industry executives seemed to understand (or care) about the significance of the MP3 audio format. iTunes software, (released Jan. 9, 2001) had been out for about two years but was still largely undiscovered by the masses. Its soon-to-be-famous store would arrive in April 2003. For the music industry it was a time of chaos, confusion and highly charged emotions.

At the beginning of 2003 a grand idea began to root in my head. An idea so simple, powerful and far reaching that I was sure it would be instantly adopted by music industry leaders. On Jan. 10, 2003, *MusicRow* magazine published my open letter to the heads of the then six major labels, Rolf Schmidt-Holtz, Doug Morris, Andrew Lack, Thomas Mottola, Alain Levy and Roger Ames. The editorial was titled **Call To Arms: A Digital Manifesto.**[1] In the letter I outlined a bold plan and warned of the consequences of inaction.

"The great companies you represent will be rendered impotent unless you act unilaterally to face an issue as important to our industry as the invention of the phonograph— the reality of the digital age," I wrote in 2003. "We desperately need your leadership to transition into this new world."

In a daydream I saw myself blanketed by a blinding Wall Street ticker tape parade, standing on a flowery float waving benevolently to my millions of new fans and surrounded by adoring NFL cheerleaders. It was a hero's welcome for having saved the music and its creators. But unfortunately, almost a decade later, the ideas have yet to generate mainstream discussion and my parade remains a dream.

In 2003 I naively believed the simplicity and wisdom of asking people to pay on the way into the digital store would be immediately self-evident. But I was wrong. In the real world choices can be clouded by politics, vested interests and a host of other issues.

I saw up close the complexity of asking an industry to change when I presented the Digital Manifesto concept to the Country Music Association Board of Directors in the early Spring of 2003. It was common practice for members to discuss new technology at meetings. In my few allotted minutes I argued for the creation of two new digital revenue streams for copyright owners—a mandatory Internet access fee for consumers and a royalty on blank recordable media. "The logical intersection of consumers and digital content," I explained, "is the Internet Service Provider. The ISP is the perfect Internet toll booth. In return for paying the toll, consumers get access to everything online. So the user experience would feel like free, but intellectual property owners would be compensated."

A few CMA Board members expressed privately they thought the idea was innovative, but hard to implement. However, most of the approximately 65-member group either didn't grasp the plan and/or dismissed it as purely academic and not practical.

Unfortunately, since the writing of the Digital Manifesto letter, we've seen chaos spread throughout the industry. Downsizing and acquisitions, like a grotesque tail wagging the dog, have reshaped the entertainment industry sending it in directions which have hurt the creative and business communities. According to the RIAA, U.S. music shipments have shrunk 50% during the last decade and over $8 billion dollars of retail revenue has evaporated. Additionally, the number of major labels has decreased from six in 2003 to three (including the 2012 acquisition of EMI by Universal Music Group.).

Paul Resnikoff, Publisher/Founder of *Digital Music News,* writes[2], "After a decade of drunken digitalia, this is the hangover that finally throbs, is finally faced with Monday morning, finally stares in the mirror and admits there's a problem." He lists six points to illustrate the headaches: "(1) No, artists can't simply tour and sell t-shirts. Shockingly few indie artists can pull this off; (2) The recording is now effectively worth $0; its surrounding ecosystem has collapsed; (3) Spotify is not a beneficial solution for artists.

Certainly not right now, and quite possibly, never; (4) Kickstarter will mean something to artists in the future, but only to a relative few. This will not replace the vast financing once offered by recording labels; (5) DIY is rarely effective, and almost always gets drowned by the flood of competing content; (6) Sadly, most artists are worse off in the digital era than they were in the physical era."

Over the years I've come to realize that the Manifesto catch phrase, *Pay On The Way Into The Store,* was merely a starting point. A more detailed, iteration of the plan is required if it is to be meaningfully debated and given serious consideration.

A decade older (and perhaps wiser) I also see that business realities may mean that change has to come from the bottom up in addition to the top down. If music industry stakeholders can be convinced of this plan's merits and motivate individuals to spread the idea across a wide range of social media channels, then perhaps as a group we can influence the digital discussion.

Remarkably, years later, even as consumers wield powerful mobile smartphone hardware and faster bandwidth extends to new areas like the automobile dashboard, *Pay On The Way Into The Store* continues to be the basis for a solid and comprehensive economic digital entertainment industry solution.

So here goes a deep dive on the Digital Manifesto, unplugged, fully-formed and modestly renamed *The Digital Solution.*

The goal is simple—to place the entertainment industry on solid footing so that as the digital future unfolds, the creative community and intellectual property owners can be fairly compensated and not be left behind. There's no time to waste…

2. HERE IN THE REAL WORLD

Sometimes the toughest part of explaining a big idea is picking the perfect place to begin. In this case however, the choice is easy, we will start with the powerful concept, *Pay On The Way Into The Store*.

Walmart, Target and your favorite upscale department store have many things in common. They set up cash registers near the exits, put electronic tags on the merchandise and charge people for purchases as they leave the store. At night, the owners can lock the doors and be reasonably assured that the store and its merchandise will remain safe and untouched until the next morning when they will again open for business. This classic scenario describes the typical bricks & mortar store. Digital strategists sometimes nickname physical vendors "analog," thereby separating the world of objects we can touch from the virtual online world which is created from 1s and 0s.

But what about going to a movie or football game? Paying as you leave the theater or stadium would be clumsy at best and perhaps almost impossible as throngs of people crowd out the doors. And would you charge everyone the same? How would you know where they sat? Should they pay more if their team won? Less if they lost? If they really enjoyed the experience should they pay more, or pay nothing if they found it dull?

Smart business people quickly realized that paying on the way out was not a smart way to run certain businesses. In fact, it makes so much sense to charge people on the way *into* a football game, for example, that we don't even think about it. It allows us to reserve the seat we want at a cost we are willing to pay and completely eliminates

collection problems for the business owner. Even a young child understands it—you don't get in without a ticket and you don't get a ticket without paying.

An entrepreneur simply has to decide upon the best way to operate his or her particular enterprise. In the above examples the answer was obvious. But as we've seen in the music industry—picking the wrong method can be disastrous.

Once you accept that both business models—pay on the way in or the way out—make perfect sense (when properly employed) you can then bend the ideas to fit specific situations. Have you ever been to an *All You Can Eat* buffet restaurant? One flat price is charged, sometimes on the way in and sometimes on the way out, depending upon the price and ambience of the venue. Want two desserts, fine. Seconds on roast beef? No problem.

How do they make money when extra large appetite customers get into line? It's a numbers game based upon averages. They figure out the average cost per person and then price everyone accordingly. What makes the business work is customer volume. The owners expect to lose money on some customers and make more on others. They accept a strategy based upon averages because customers would be insulted if they were priced according to how fat or skinny they look. So as long as the entrepreneur properly adjusts the average price to include a sustainable profit margin the business can operate successfully.

And finally, governments and insurance companies illustrate a third model by pooling payments and spreading risk across large groups of people. To support public goods, like roads and schools, governments require *all* citizens to pay a small fee. With lots of people each paying a little, the end result is a large fund. Today's streaming distributors like Spotify, Beats or Pandora unfortunately face a different reality—they have a relative few people paying subscription fees. For example, after several years Spotify has attracted only 6.5 million paid subscribers in the U.S. (June 2015) which has a population of 320 million. In an effort to boost numbers Spotify and other companies are lowering prices for college students and offering bundled deals for families.

We just explored a few basic ways to charge for goods and services—pay on the way in or on the way out; pay for exactly what you purchase; or pay for an average

consumption with "all-you-can-eat" privileges and finally pay to support a public good usually defined as roads, a bridge, or supporting the military. Could music also be a public good in the digital era where distribution is virtually impossible to control? (More about that later.)

How do these basic economic models relate to the tragic entertainment industry disaster we are witnessing? Why are publishers, songwriters, artists, labels and many others suffering the effects of downsizing and losing jobs? Could the problem be because music industry leaders simply haven't found the best way to charge for their product?

As this book heads to press there is a great deal of activity among legislators regarding Consent Decrees and the Songwriter Equity Act (SEA), but it is unclear exactly how the Justice Department and Congress will resolve these issues. Looked at simply the struggle is about allowing songwriters and publishers to negotiate using free marketplace rates and not the pricing set by laws, almost a century old, that do not allow fair compensation in the digital era. If publishers are allowed to negotiate based upon free marketplace rates it will result in more money being paid to creators. But the bigger question is, will those adjustments be enough to support an industry currently shrinking faster than a cheap shirt in a hot dryer? Spotify is hundreds of millions of dollars in debt and desperately cutting rates to attract subscribers. Pandora's latest reports say they lost over $11 million in just the last quarter (Q2 2014). The music industry is also under duress. Will negotiating better fees based upon this small group of subscribers solve the problem, or merely be a temporary band-aid? Are leaders mistakenly just rearranging chairs on the deck of the Titanic? Is there a realistic and attainable break even point for the streaming services, especially if they have to increase royalty payments?

To continue developing *The Digital Solution* let's briefly return to the time when Napster exploded and review what happened vs. what might have happened.

3 THE NAPSTER CHAPSTER; WHAT WENT WRONG?

Every entrepreneur dreams of creating a company that becomes a household name. But when Napster was born in a college dorm room at Boston's Northeastern University, it's unlikely that 19-year old Shawn Fanning was thinking about planting seeds for corporate success. He was trying to solve his roommate's problem of locating and indexing downloadable music files. Regardless, the quirky company, named after Fanning's hairstyle, literally exploded almost overnight.

Napster began in beta form during the summer of 1999. By December 1999 the Peer2Peer (P2P) file sharing program had gathered so much attention that the R.I.A.A. launched legal action. At its height, Napster had 80 million registered users, but its remarkable life span was cut short when it was legally forced to close on July 11, 2001.

Napster was a brilliant service which turned music into the killer app overnight. Unfortunately and importantly, compensation for creators was not included in the program's business model. This serious omission gave record labels and intellectual property owners every right to object. But did creators choose the best course of action?

Wired.com writer Brad King's now famous article, *The Day The Napster Died* (Wired.com; 5/15/02) offers a tech writer's perspective on the music site less than a year after its closure.

"...The revolutionary software allowed people to use the Internet to do what they had done for years in neighborhoods, schoolyards and concert venues: They swapped

music," King wrote. "Within months of its release, Napster was the Internet's killer app. Napster and its founder held the promise of everything the new medium of the Internet encompassed: youth, radical change and the free exchange of information. But youthful exuberance would soon give way to reality as the music industry placed a bull's-eye squarely on Napster."

How did it work? Each user was required to register with an email and password and then download the Napster software to his or her computer. The software allowed each user to specify which MP3 files were shareable on the user's machine and access similar shareable files on the machines of all the other users in the P2P network. The result was ingenious. Hard to find bootleg recordings and out of print music suddenly became available making the service a joy for music enthusiasts. What's more, bandwidth for the downloading was seamlessly shared and contributed by all the Napster users.

The critical nature of "getting it right" during the Napster period cannot be underestimated. Internet habits were just forming, laws were being written for the digital era and consumers were still accustomed to purchasing music. Ten years later we have the advantage of time to show us how badly corporate media's decisions turned out. Yes, Napster users were stealing the music. Something had to be done. But wasn't there a better way to handle the situation than using the courts to destroy everything? Let's look at some of the top level dynamics of the situation.

The Lost List

Napster was not all bad. The music industry had never before been able to aggregate 80 million active music users in one place and reach them via e-mail. Selling music on shelves in brick and mortar stores offered the music industry no direct relationship with its customers. Napster offered musicians, labels and fans the ability to communicate and direct market on a one-to-one basis. This amazing resource should have influenced the industry's digital plans, but people were only just starting to realize the power of email marketing.

Fanning and his Napster team (perhaps unknowingly) had engineered a high profile threat that the recording industry felt obligated to answer with full force. RIAA lawyers, like angry bees, were sent streaming out of the hive with stingers on full force to litigate and destroy the new music distribution system.

What Else Could They Have Done?

Let's examine Napster with respect to the discussion about business models in the previous chapter. You'll recall we looked at a few basic ways to charge for goods and services—pay on the way in or on the way out; pay for exactly what you purchase; or pay for average consumption with "all-you-can-eat" privileges and finally use the power of size to get large numbers to each pay a little. Was one of these ideas right for Napster?

Napster's password/user name log in provided a perfect tollbooth for a *Pay on The Way Into The Store* subscription model. For example, if Napster convinced its 80 million (and growing) users to subscribe with all-you-can-eat privileges for $10 per month or $120 a year it would have generated $9.6 billion dollars. Unlimited music for about the cost of buying 8 CDs annually would have represented an excellent consumer value. But was it also a good deal for an industry showing $14.6 billion in 1999 sales? The answer appears to be yes.

Monetizing Napster, would have almost doubled existing net industry revenues. Especially when you consider that digital sales, unlike physical sales, have little or no cost of goods sold associated with them. Napster would also have created an incredible direct marketing conduit to reach its consumers. Any eventual losses in physical sales would have been mitigated by new revenue streams from ancillary items such as tickets, videos and merchandise made possible through email marketing. It's likely that sales of physical product would erode over time, but the effects on the industry from strong digital monetization, plus new revenue streams fueled by email marketing would have been sustaining.

What Went Wrong

In hindsight, creating a subscription model for Napster instead of destroying it could have made a significant difference in the shape and size of today's music industry. Why didn't it happen?

Although we will probably never know the exact details, it appears the recording industry had fatal misconceptions about the nature of the Internet. For example, they believed they could "lock up the store" and completely control music distribution using digital rights management (DRM) software. But after several high-profile, post-Napster DRM fiascos, and much to its disappointment, the industry finally accepted that

securing the Internet store was not possible. Ultimately the idea of using DRM was abandoned completely.

Jim Griffin, Managing Director at OneHouse LLC. and a well known agent for constructive change in media and technology, testified before the Senate Judiciary Committee at the famous Napster hearings in July 2000. He told this writer recently in an interview, "Looking backwards and especially based upon history I doubt you'd get a defense from anyone in the industry saying Napster was handled well. It's a bit like how you might feel sitting at a poker table when someone with a lot of money enters the room. Your thought should be how to win the money from them, not send them away. The answer with respect to digital should always end with a license. We should license because even if we say "No" it doesn't mean that any less music is going to get out."

As Griffin notes, labels miscalculated by thinking that shutting down Napster would eliminate the distribution threat from file sharing and P2P software. Napster's technology was stored data in a central server that made it easy to identify users. Unfortunately, the post-Napster generation of P2P programs protected users by making the swappers invisible and untraceable. A few years after Napster was shuttered, illegal file sharing was more popular than ever. Estimates of the ratio of illegal to legal downloads were as high as 20 to 1. Unfortunately, it was a classic case of turning a bad situation into one that was even worse.

Distribution and Scarcity Controls Pricing

Basic economics dictates that pricing is directly related to the balance between supply (scarcity) and demand. Before Napster, labels maintained complete control over decisions about format, release schedules and more which gave them the ability to set prices. Introducing new formats such as vinyl, cassette and CD also allowed labels to resell classic music multiple times. It was a brilliant cash cow strategy that had placed billions of dollars in industry pockets creating a $14.6 billion dollar[3] U.S. industry at its peak in 1999. However, the new P2P virtual world threatened to erase that control. The recording industry never graduated Summa cum laude in Internet studies, but they were masters of analog marketing and immediately recognized the threat posed by the new P2P functionality.

CDs were costing about $16 each in 1999. But consumers suddenly realized they

could purchase a blank CD for $1 and burn it with digital files shared (illegally) from person-to-person for free. They began asking, "Why are music CDs so expensive?" Napster and the MP3 format were unhinging the very foundation of the music industry economic model.

Labels were in no mood to imagine the ways this new distribution behavior might bring exciting and profitable new opportunities to replace those it destroyed. People were stealing their music and they were mad.

"If we aren't able to control the quantity and destiny of music," agrees Griffin, "then it won't lend itself to a product form and its price will fall to its marginal cost of delivery. Once we learned *we had no choice* about losing control of music's quantity and destiny the next step was to think about the new business model that lies ahead."

"It led me to thinking deeply about how we monetize anarchy or risk," Griffin continues. "There are many things we can't control like when we die or if our car has an accident. It seems that creators also undergo risk when they create. Could actuarial models of compensation work for creators and how might we structure those models? I looked back in time to see who has faced similar challenges to what we are facing. When Ronald Reagan first put baseball games on the radio people complained, 'No one will buy a seat.' Later when you could watch the game at home on color TV people asked why would you go to the stadium? Too often we cling to the vine that keeps us off the jungle floor without thinking about how to grab the next one to propel us forward. I call these product-to-service transitions Tarzan Economics. Today, sports teams work hard to get on basic-tier cable because then they get paid even by people that don't watch the games. If you are on the basic-tier as a football team you are going to get money from every cable household whether they watch the game or not and that actuarial model piles up a lot of money. If you can get a little money from a lot of people under a lot of circumstances, you can pay for the team. John F. Kennedy signed the Sports Marketing Act in 1961 that allows hockey, basketball and football to market together in a way that otherwise would have violated anti-trust laws. I'm also for relieving the creative industries of their anti-trust restrictions."

Griffin's actuarial concept embraces the *Pay On The Way Into The Store* and public goods models by getting everyone to pay a little.

Couldn't We Get Along Together?

Was Napster about compensating intellectual property owners or a fight to control distribution? Could it have been saved, monetized and made legal? Not everyone agrees. But most everyone acknowledges it proved a monumental wake up call to the fact that the properties of the physical and digital worlds are not identical. Ultimately the label's haste resulted in a missed opportunity that haunts the music industry to this day.

4. TOLL BOOTH AHEAD

Hopefully, the phrase *Pay On The Way Into Store* is becoming lodged in your brain. Perhaps you're also patiently waiting to hear more details about collecting and disbursing those payments? So let's get started.

When we suggest paying on the way into the store, the "store" signifies the entire Internet or information highway as it was called around 1999. Digital surfers all have one thing in common, they obtain online access through an Internet Service Provider gateway (ISP) for a fee. Some of the larger and best known ISPs are Comcast, Verizon, AT&T and AOL.

These ISP companies are naturally positioned as internet toll booths and therefore the perfect place to collect a *Pay On The Way Into The Store* mandatory copyright fee from consumers before they head online. Chapter 6 will discuss some of the many reasons why this fee is necessary, reasonable and likely the only way to insure our society continues to enjoy the many benefits of music. But for now, let's see how it might work.

The StreamCollect Fund Overview

The plan begins with the creation of the StreamCollect Fund, a holding tank where payments are aggregated before being transferred to the distribution entities. The payments come from three sources—mobile ISPs, broadband ISPs and online streaming music companies. The ISPs will each collect a low monthly StreamCollect fee per subscriber. Companies that stream music will pay a percentage of gross revenue to the StreamCollect fund.

The ISPs are already billing each consumer, so the process only requires the addition of a line item on monthly bills. In return for this service, ISPs will retain an administrative collection charge. Net collections would then be passed directly to StreamCollect for distribution to rights owners.

Why ask the ISPs for help? Can't we just sit back and wait for the streaming companies to gain more subscribers?

Let's put the streaming music subscription numbers in perspective. According to the RIAA, at the end of 2011 there were less than two million U.S. paid internet music subscribers to all services such as Spotify and/or Pandora. Two years later, at the end of 2013, RIAA cites 6.1 million paid subscribers and 7.7 million in 2014. Industry distribution sources cite 9.3 million paid U.S. subscribers at the end of June 2015 which includes Spotify, 6.51 million; Rhapsody, .9 million; and Google Play, .94 million. Competition is fierce and a variety of new players have entered the space including Apple Music and Amazon Prime Music. Many of the companies are now offering deep discounts (up to 50%) and family plans to entice customers which realize they can also listen to music for free.

Although the U.S. streaming subscriber count is growing it remains insignificant when compared with statistics that show a country with over 192 million mobile, 100 million broadband households and an overall population of 320 million. Having *everyone* pay on the way into the store would insure that individual payments can remain low, because the plan's massive scale creates a pool large enough to offer fair compensation to intellectual property owners.

Streams Not Downloads

The StreamCollect Fund will apply to all types of music streaming, but not downloads or physical product. Measuring performances of streams is intuitive, but downloads are different. How often a download is listened to is difficult to gauge. Also, the current royalty process for downloads is well established. Therefore, *downloads are excluded from the Digital Solution and should retain the status quo.* Many observers believe that streaming will replace downloads over time as consumers become convinced they can access their favorite music wherever, whenever and however they wish. Regardless, this plan lets the marketplace decide.

One Digital Royalty For Streaming

In the physical world there is an easily understandable and definable distinction between mechanical and performance royalties. CDs on Wal-Mart shelves produce mechanical sales. Airplay on your local radio station is performance income. On the Internet however, these terms don't fit nearly as well. In fact, trying to apply them to streaming situations has already produced contentious lawsuits from well meaning parties who disagree about what online activity qualifies as a mechanical royalty, a performance royalty and/or what is both. The fact that even the professionals can't easily discern which digital behaviors create which revenue streams is proof enough that the digital royalty system for streaming should not be a carbon copy of the analog policies. Therefore the new plan suggests a single unified digital streaming royalty that will be shared by all stakeholders.

All Streams Are Created Equal

Current copyright laws also differentiate between on-demand/interactive streaming where the user chooses a song—and webcaster streaming where the programming is more random like listening to the radio. This architecture, although well meaning and intended to protect copyright owners, is needlessly complex and mostly just serves to stifle commerce and innovation. Under the Digital Solution *every stream-per-user will be counted equally,* giving companies more freedom to innovate and create exactly what consumers want. The distinction between on-demand and webcaster is eliminated which also simplifies the distribution process for rights holders. As long as rights holders are being fairly compensated, what difference does it make whether a stream is picked by the user or programmed by the streamer?

Digital Streams Are Monitored

Once we accept the idea of a unified digital royalty and the equality of streams, then our goal becomes to count each time a file is streamed. Identifying each individual stream seems a Herculean task, but the power of the Internet works nicely to aid intellectual property owners in this pursuit. There are multiple ways to accomplish this "file tagging" but implementation could be decided by a specially chosen technology committee. The data could be generated by individual web sites and sent to a central source, or it could be collected from "fingerprint robots." For example, a New York company, TuneSat already claims to monitor online streaming usage and is an example of a partner that may be suitable to perform this function.

A song's usage as compared with the activity of all songs will ultimately determine its payment percentage of the StreamCollect royalty pool for a given period. Royalties paid to all the songs accessed during a period will equal 100% of the fund, minus administration fees. The idea of determining royalty amounts based upon usage is not unlike the system which performing rights groups currently employ to calculate performance royalties at terrestrial radio.

Statutory License

A statutory license means that any startup company can begin streaming music online as long as they pay a set fee (in this case a percentage of gross revenue). Currently, companies wanting to offer on-demand music are forced to undertake lengthy and expensive negotiations with multiple individual rights owners. These negotiations typically involve large advance payments and make starting a new company daunting. Charging music companies a fixed rate will stimulate investment and technological innovation plus allow businesses to plan their expenses with a fixed cost structure similar to current royalties for terrestrial radio stations.

Safe Harbor

In return for making payments to StreamCollect, rights holders also agree to grant internet music companies and ISPs added legal protection in the form of safe harbor status. Safe harbor essentially means rights holders agree not to sue for infringement and is a key benefit under the *Digital Solution* plan, especially for ISPs. The threat of being sued is a stumbling block in today's Internet dynamics. All too often it forces copyright owners and technology companies into adversarial positions, especially when new ideas are seen as a possible threat or roadblock to intellectual property compensation. This struggle hampers innovation and limits consumer choices. When consumers pay at the ISP toll booth however, fair compensation is assured. The combination of safe harbor and statutory license resolves the adversarial relationship between technology and copyright owners. The user experience feels like free, but most certainly is not. Everyone pays their fair share.

Summary

The five main bullet points discussed in this chapter...

- Creation of StreamCollect streaming royalty fund
- Mobile and broadband ISPs will invoice consumers for a monthly copyright fee in return for safe harbor status and an admin fee.

- Streaming music companies will pay a fixed percentage of gross revenue to StreamCollect and in return are granted a statutory music license plus safe harbor status.
- StreamCollect covers streaming usage only. Digital download and physical sales practices remain unchanged.
- The distinction between on-demand and webcasting is eliminated. All streams are equal, one stream = one use.

5. COLLECTING THE FEE

A detailed accounting of collections for the StreamCollect Music fund is provided in this chapter. A diagram, *Collecting Revenue* is provided to make it easier for readers to follow along. Please keep in mind the dollar amounts are intended to be reasonable estimates to show how the fees might work. Actual rates (and ISP admin fees) will have to be agreed upon by those involved. Funds are collected from three sources, Mobile ISP customers (smartphones and tablets); broadband ISP customers; and companies that stream music online.

Paying The ISP Tollbooth

ISP customers would pay $1.30 per account, monthly or $15.60 per year. Many customers will have mobile and broadband accounts and therefore pay a total of $2.60 per month. About 11% of these funds would be retained by the ISPs as an admin fee for performing the collection service. As mentioned previously, ISPs also receive the all-important incentive of safe harbor legal status which means they cannot be sued for copyright infringement.

Here's how it adds up. According to comScore, there are about 192 million U.S. smartphone users (July 2015). Having 192 million users each paying an annual rate of $15.60 generates $3 billion per year. The 100 million broadband households would pay the same charge, adding an additional $1.56 billion. These account fees, collected by all ISPs, would appear as monthly line items on the invoices ISPs are already sending to customers. After subtracting admin fees of approximately $560 million, ISPs would pass

through to the StreamCollect fund an annual total of $4 billion based upon the number of current users.

(Note: In determining a proper ISP monthly consumer fee, a base charge of $2.60 was deemed reasonable. However, many consumers, have separate broadband and mobile accounts and as a result might be getting charged twice that amount each month. Did it seem productive to create complicated rebate mechanisms for the large majority of users with both accounts? No. Rather than build another administrative expense into the plan, it seemed more efficient to merely split the fee in half.)

Companies Streaming Music

The third source of StreamCollect revenue comes from companies that are streaming music online and benefitting from its use. Included in this group are both pure play Internet operations such as Spotify, Pandora, rdio, and Slacker plus terrestrial radio stations that simulcast online. Remember that unlike today's complex royalty environment, all forms of streaming (on demand and webcaster) are considered equal. This change allows companies to offer both types of streaming plus create new hybrid ideas that might further engage consumers. Under the *Digital Solution*, these companies will each pay the larger of a set percentage of gross revenue (15%) or a minimum fee. The 15% rate is approximately what satellite radio pays currently, but an actual rate will have to be negotiated. The important thing is that companies will not have to pay large advances or negotiate endlessly to be able to launch a new business. They will have predictable expenses. Company revenues are conservatively estimated to contribute approximately $500 million in additional annual funds. Companies paying into StreamCollect would also get safe harbor status and a statutory license. The Company category of collected funds is expected to grow rapidly as new players take advantage of the statutory license and lowered barriers to entry created by these new rules.

Sound Exchange, already serves the licensing function for non-interactive webcasters. Making them the responsible partner, with StreamCollect, for licensing all businesses that stream music (non-interactive and interactive) could be a logical extension of their duties. Sound Exchange's increased operations expenses, incurred by added company licensing responsibilities, will easily be offset by its increased collections totals under the StreamCollect plan.

Collecting Revenue
For The
StreamCollect Music Fund

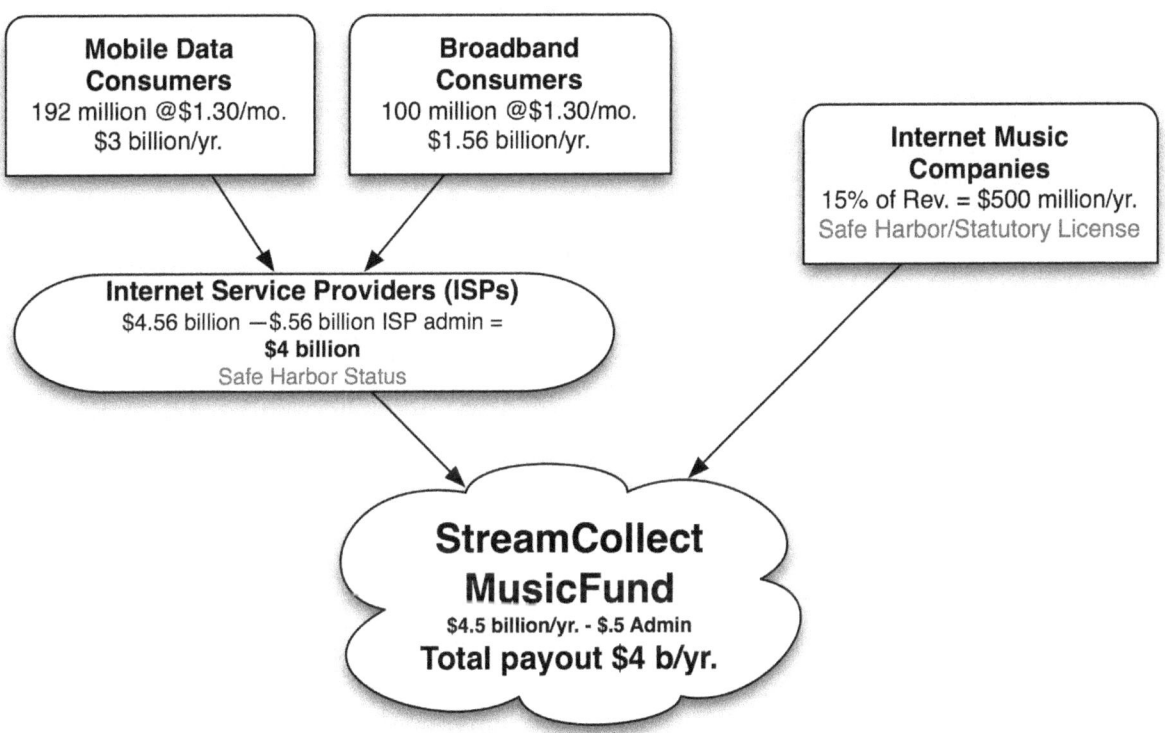

- Applies to Digital Streaming only
- All streams are equal (webcaster, interactive, on-demand); one stream=one use
- U.S. smartphone penetration estimated to be 192 million; July 2015 (source: comScore)

The Digital Solution ©2015 David M. Ross BossRoss Media, All Rights Reserved

As shown on the **Collecting Revenue** flow chart, and based upon the three collection sources, after all expenses the fund would distribute a total of over $4 billion dollars per year. Since the U.S. music industry is currently estimated by the RIAA to be a $7 billion dollar industry (before subtracting cost of goods sold) adding Stream Collect's additional $4 billion in revenues (with little or no cost of goods sold) would in real terms almost double the size of the industry overnight.

How might the *Digital Solution* effect the way companies offer their services? Companies would be free to create and implement their own business plans as long as they pay their revenue share into the StreamCollect pool. Competition will govern how this works and insure the best deal for consumers. As with terrestrial radio, businesses should be able to create robust offerings that rely upon advertising, sponsorships, endorsements and or ancillary revenues for support. They may also decide to create special premium subscription offerings that the marketplace will consider.

We've learned from experience that we can't lock everything up. Everyone has access and therefore everyone has to be part of the plan. In Chapter 6 we'll reflect on why it is so important for consumers to protect creators in the digital economy, and in chapter 7 we'll outline how the StreamCollect funds get distributed to rights holders.

6. CREATORS BENEFIT SOCIETY AND CULTURE

A copyright fee collected by the ISPs will help support the creative community while simplifying and encouraging innovation for online businesses that use music. But not everyone will applaud the new fee. Some consumers will undoubtedly complain for reasons such as, "I don't like music," or "I don't listen to music online."

Harvard Law Professor William W. Fisher III offers some compelling points in his book, *Promises To Keep: Technology, Law and the Future of Entertainment* (Stanford University Press, 2004)[4]. Fisher compares the dire internet-caused circumstances facing today's musical intellectual property owners with other historical precedents that have effected what he refers to as "public goods." Throughout history he asserts, governments have taken steps to, "counteract the danger that public goods will be underproduced."

"A small number of socially valuable products and services have the following two related characteristics," says Fisher. "First, they are 'nonrivalrous.' In other words, enjoyment of them by one person does not prevent enjoyment of them by other persons. Second, they are 'nonexcludable.' In other words, once they have been made available to one person, it is impossible or at least difficult to prevent other people from gaining access to them. [Public] Goods that share these features are likely to be produced at socially suboptimal levels."

Fisher's eloquent description is economic-speak for saying that once a song, movie or book is released online it becomes difficult and likely impossible to keep it from being shared and enjoyed by an unlimited number of users, many of whom will not pay for

the experience. Taken to the extreme, creators would no longer be compensated for their work and many would likely be forced to produce other less socially valuable products to earn a living.

Expressed differently, one could say intellectual property and its creators contribute to the cultural and spiritual growth of society in a way similar to other public goods. However, because online technology has made music nonrivalrous and nonexcludable (according to Fisher) it can not be supported by individuals alone. The South Carolina Department of Revenue succinctly explains this idea on its website[5] as quoted below.

"There are many services offered to citizens that could not be managed effectively under any other system. The federal government uses your tax dollars to support Social Security, health care, national defense and social services such as food stamps and housing... The city or county where you live provides water and garbage service, police and fire protection and also contributes to public schools. We can all admit that these services are necessary... Why shouldn't we just pay individually for what we use? The answer is simple: Because no one could afford it."

In the groundbreaking music manual, *The Future of Music* written by David Kusek and Gerd Leonhard (Berklee Press 2005) the authors also suggest a Pay On The Way Into The Store approach. "Another option is to institute a small fee in the form of a 'utility license' or—dare we say it—tax that would allow people to download any and all music online," says Kusek and Leonhard. "If the involved industries cannot voluntarily agree on and create such a legal structure themselves—and do so soon—then maybe the governments should do it..." A few paragraphs later the co-writers conclude, "This 'content tax' seems like a reasonable solution to the current, rather ridiculous environment in which each piece of music must be individually licensed from each rights owner, on a track-by-track basis. This new tax could be a form of insurance against online piracy, and rather than trying to sue everyone to force an overall change in consumer attitudes and behavior, the industry would simply 'tax' them."

Under *The Digital Solution* plan we call the payment a fee (not a tax) because it never goes into government coffers. After being collected it is passed on directly to the StreamCollect Fund.

Internet Porous DNA

The Internet and its unique properties dictate that information, once uploaded, is impossible to protect or segregate. This basic understanding about the porous nature inherent in the DNA of the Internet is the reason why paying on the way into the store is the best (and perhaps only) way to insure compliance and fairness for both users and creators. In return for paying the fee, consumers get rewarded with a 'feels like free' compulsory license that both encourages technological innovation and compensates creators.

Volker Grassmuck wrote an excellent paper for the *2011 Rethinking Music Briefing Book*[6] designed to help frame some of the copyright issues to be discussed during that year's annual music conference. In the article Grassmuck advances, "A Proposal For Balancing User Freedom and Author Renumeration in the Brazilian/Copyright Law Reform" that has key similarities with the ISP fee concept. In discussing why a new copyright approach is necessary for the digital domain, Grassmuck notes, "The digital revolution has fundamentally changed the media/technological basis of the production, distribution and consumption of cultural goods. Private persons, whose actions have until recently been outside the scope of copyright law, can now be producers and global distributors of creative works." Dismissing the effect of DRM as "unproven" Grassmuck states, "Repression predictably calls in the next round of the technological arms race… If cultural reality cannot be made to conform to copyright law, then copyright law has to be adapted to reality by legalizing what can not be prevented anyway and at the same time ensuring an equitable renumeration to authors."

Grassmuck is talking about a Pay On The Way Into The Store plan which he sees as necessary because, "individual private internet users owe the creators of the works they share." He adds, "Likewise ISPs and mobile phone companies that provide internet access to private homes are the logical parties to add the file-sharing levy to their monthly customer bills and transfer the money to the CMOs (Collective Rights Management Organizations)."

Onehouse's Jim Griffin together with Warner Music group experimented with ISP payment models around 2008. Their company Choruss, started talking with colleges about licensing student music usage with a flat fee. "We were oversubscribed by schools willing to pay $5 per student a month," says Griffin. "ISPs like the compulsory license,

their main concern is, will be a level playing field? If they know their competitors are also paying, then it is of little consequence. The schools by the way are ISPs for their own students. Ironically, all of these same schools have mandatory cable fees now. If you live in the dorms then you pay for cable whether you want to or not and that money goes to the TV, movie companies and sports teams whether you watch or not. I'd like to see something similar happen with music because music is a part of the culture just like TV and movie are. I don't see a huge problem with assessing these fees."

Summary

Intellectual property has always been an important part of our society's cultural and spiritual growth. Music is everywhere. It is used in religious ceremonies, as part of public gatherings and in so many additional ways. Our world would be a different place without the songs and singers that inspire us so often in our daily lives. What has changed in the digital age is that music no longer needs a physical medium to access it. Hold-in-your-hand formats like vinyl, cassettes and 8-tracks have been replaced by the streamed and downloaded MP3 file which has no physical shape or form.

The last decade has clearly shown that the music industry is adrift in search of a business model which can satisfy and create value for both consumers and creators. *Pay On The Way Into The Store* is not a new economic concept, but a growing number of voices are suggesting that it may be the best approach for digital music in general and streaming specifically. This writer called for it in an open letter published in Nashville's music trade magazine, *MusicRow*, on Jan., 10, 2003. Professor William Fisher's book quoted in this chapter suggested a similar plan in 2004, and Kusek and Leonhard's *Future of Music* echoed the need for a "utility license" solution in 2005.

The magic of evolving music technology allows us to experience new wonders. But technology, without great content to elevate it, can be reduced to a mere parlor trick. *Pay On The Way Into The Store* ensures that the exchange between creators and users is balanced and fair and therefore it is most assuredly in the public's best interest.

Read on to see how the money will get divided among rights holders…
Chapter 7: Distributing The StreamCollect Fund.

7. DISTRIBUTING THE STREAMCOLLECT FUND

If artists, songwriters, publishers, managers, record labels *and* consumers agree that *Pay On The Way Into The Store* is the right solution, it's easy to see how it would create substantial revenues. Chapter 5 outlined a plan for funding a StreamCollect pool. Equitably dividing the new royalty reservoir, is also achievable. Most importantly, allocating distributions from a growing pool of money is infinitely preferable to dividing remnants from a shrinking industry that has lost over 50% of its value in the last decade. Ultimately, all "boats" will benefit from a rising and reliable royalty tide.

Fortunately, many of the pieces necessary to distribute the annual estimated $4 billion StreamCollect fund already exist. The entities charged with this responsibility would include the performing rights societies— ASCAP, BMI and SESAC; plus Sound Exchange which currently collects statutory license royalties from cable music channels, webcasters and satellite radio.

Understanding The Status Quo

Currently the world of copyright royalties is a complex tangle divided between two main groups—song publishers and record labels. Publishers share revenue with songwriters. Labels share mostly with artists and producers. This structure works smoothly in the analog world where supply, demand and pricing is controlled by locking up the stores at night. But as previously discussed, the digital matrix upsets the established royalty balance because online music is easily copied and shared with little concern for intellectual property compensation.

Today's streaming royalties represent a well intentioned, but extremely cumbersome process. Sites wishing to stream music and/or music-with-video have a legal gauntlet to run and a laundry list of royalties to pay in order to comply with existing laws. There are mechanical royalties, a sound copyright, a performance copyright, both statutory and individually granted licenses and more. Streaming companies are divided into two basic types which further complicates the licensing and royalty process—on-demand or interactive streaming which gives users control over what songs they play; and webcaster streaming which is more like listening to the radio. The statutory webcaster license (radio type programming) is automatically granted by law to users in return for paying the appropriate per user/per stream Sound Exchange and PRO fees. However, to legally offer interactive streaming, sites such as Spotify, Rhapsody, Beats and rdio must license, negotiate and pay individual rights holders directly; a complex, time consuming and expensive process.

The Digital Solution proposes to treat both streaming formats the same, especially with respect to offering both the benefits of a statutory license. Placing all streaming models under a statutory license will stimulate innovation, new technology and spur job creation. As discussed throughout this text, the economic gains derived from the scale of this plan dwarf any concerns by rights holders about offering statutory licenses.

Currently, streaming performance fees are collected by BMI, ASCAP or SESAC and distributed to publishers and songwriters. The streaming sound performance copyright gets collected by Sound Exchange and goes to labels, artists, producers and musicians.

Confusing? "Yes." Even professionals who work in the business find this licensing maze a serious and expensive challenge to successfully navigate.

Distributing The StreamCollect Pool

Dividing the net $4 billion pool can be simplified if copyright owners consider all streams equal and create a unified royalty which pays both webmaster and interactive uses at the same rate. We are already seeing abundant marketplace proof that the streaming model is growing rapidly and expectations are that trend will continue.

There are numerous experienced organizations in the collection/distribution marketplace—Sound Exchange, ASCAP, BMI and SESAC— which should be utilized

to facilitate distribution. These resources will also be invaluable in smoothly speeding the transition to the new plan.

The Split

A main concern to all parties will be the negotiated split between publishers and labels of the annual $4 billion StreamCollect pool. The exact split will need to be negotiated between the groups but it might end up with perhaps 40-50% earmarked for publishers and songwriters and the remaining 50-60% for sound creators of the record —artists, musicians, producers and labels. On one side of the table will be record labels, representing producers, musicians and artists. Sitting across from them will be publishers and songwriters. Some writer/artists will have interests on both sides of the table. Admittedly, dividing the fund between these main stakeholders will require good faith negotiations and a respected mediator. Let's see how it might be achieved.

In the analog world, the statutory mechanical rate apportions labels about 90% of the sale price and the remaining 10% goes to publishers. But part of the label's 90% includes a physical world allocation for expenses such as manufacturing, printing and shipping which lower label profits. Because there are no manufacturing or printing expenses for digital streams, the StreamCollect label/publisher royalty split can move toward a more equal balance and still greatly enhance revenues for both creative groups. For our example we have arbitrarily chosen a split of 45/55.

ASCAP, BMI and SESAC presently collect and distribute song performance royalties to songwriters and publishers. These funds are generated from the performance of songs on terrestrial radio and other uses plus from digital performances. The performance rights groups are already connected with the rights holders, understand how to service their needs and therefore should manage the song share of the StreamCollect Fund. These three entities currently collect about $1.8 billion annually. The addition of mostly new revenue from the StreamCollect songwriter/publisher share, according to our example, should double their present-day collections.

Sound Exchange is the logical choice to manage the sound recording share of the fund, which goes to artists, labels, producers and musicians. It was appointed by the U.S. Library of Congress as the sole entity to collect and distribute statutory royalties from satellite radio, internet radio, cable TV music channels and streaming platforms. Sound

Distributing The StreamCollect Music Fund

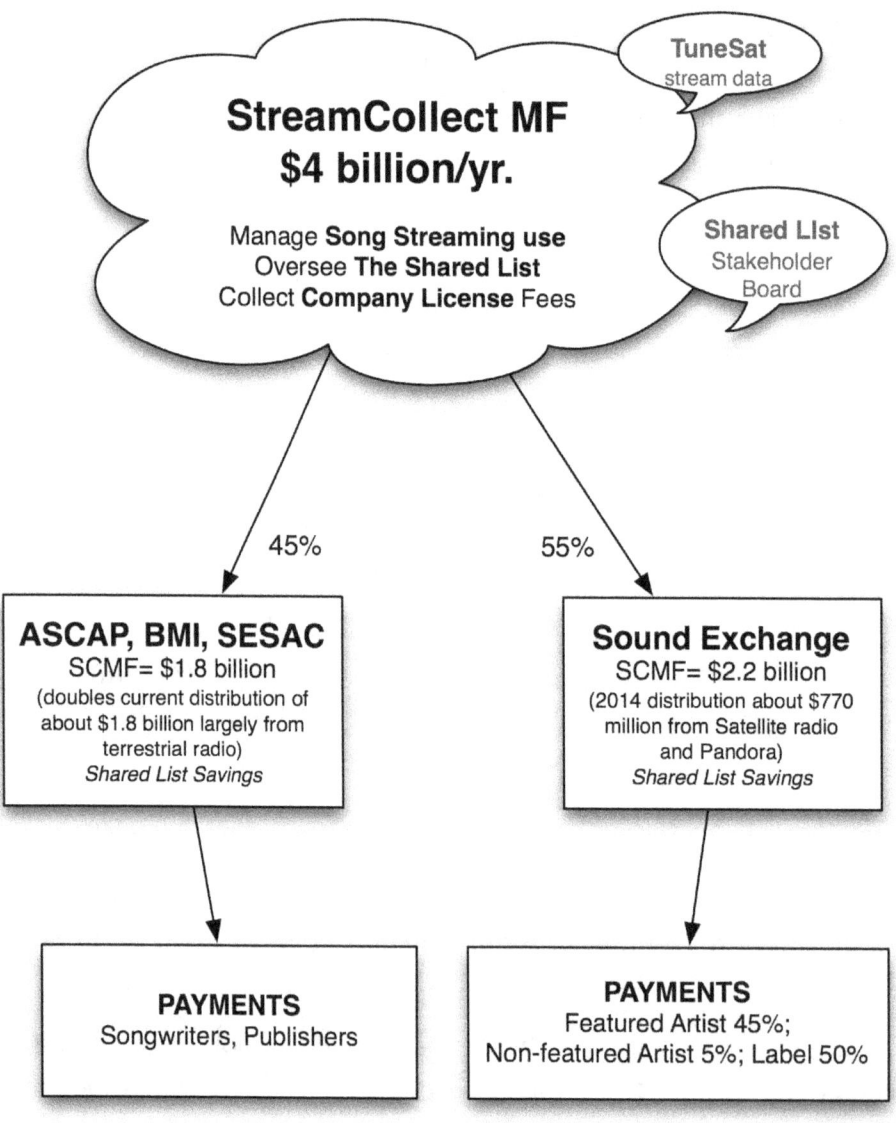

Exchange, distributed around $770 million in 2014. The addition of collections from the sound recording share of the new streaming royalties pool (about $2.2 billion) would greatly increase that total. (Sound Exchange also "earns" and distributes a large share of its total royalties from cable TV music channels and satellite radio. Those functions are separate from StreamCollect which relates only to internet streaming usages, so they are unchanged.)

For purposes of example, our diagram shows 45% of the pool going to ASCAP, BMI and SESAC; and 55% passed through to Sound Exchange.

Stream Tracking And The List

To operate at peak efficiency however, the system still needs two important tools—a reliable means to measure music streams, and a comprehensive, centralized, machine-readable database to house each song's data. Armed with data about total streams, then an individual song's plays as a percentage of the total plays from all songs will determine its payout. TuneSat is an example of a company that could be a partner in measuring usage.

Currently each of the above named collection entities also maintains its own proprietary patchwork of data. A new shared database, overseen by a Board of Directors with representatives from each entity should engender confidence and bring a new level of efficiency for rights holders.

8. A BLANKET AND A LIST

We have discussed how the StreamCollect Fund would be collected and distributed, but to successfully implement *The Digital Solution* for the long term, the plan needs two additional items—a sturdy, well-crafted master list; and a comprehensive blanket license representing all commercially released material.

There are many music licensing systems and databases currently in place such as BMI, ASCAP, SESAC and Sound Exchange. In each case these collection arms gather fees from analog and/or digital sources and then, using their own proprietary databases split the money amongst their membership. These databases contain contact information about the ownership of each song including publishers, writers, artists and more. Tracking the proper beneficiaries can be a very complicated process because songs often have multiple publishers and writers who are not always equal owners of the copyright. In addition, many of the different databases contain overlapping information.

As all d-base designers know, having one centralized list is more reliable than multiple databases containing bits and pieces of the same material. Consider, for example, when a songwriter change-of-address occurs. In a centralized system the address is updated once. In a system of multiple databases, records must be updated in multiple places, increasing the chance for errors and omissions. A centralized, machine-readable database for digital streaming collections and distributions would speed royalty administration payments. Equally important, it would simplify compliance for owners of intellectual property giving them a one-stop shop to register and keep their data updated regularly.

Not surprisingly, the need for a master list of copyright data is already being voiced in a variety of discussion venues.

In Nashville, MyWerx.com[7] has taken an innovative approach toward creating a central information crypt. "The foundation of our platform is a validated-wiki, copyright registry," the company explains. MyWerx issues a series of automated emails to all parties with an interest in the work. Critical data such as "titles, author names and their ownership interests," is then validated. Each step in the validation process requires consensus of the parties. MyWerx wisely notes, "Copyright viability and value is at risk when the market interested in using them must invest hours of time tracking down the owners or licensing agents to obtain permission."

The World Intellectual Property Organization (WIPO) several years ago began constructing an International Music Registry[8] (IMR). Still in its early stages of development, IMR is a centralized global database for rights holders and says its goal is "to facilitate licensing in the digital environment by providing faster, easier and simpler access to reliable information about musical works and sound recordings throughout the world." More specifically, "The IMR seeks to create an international system that provides a single access point to all the different rights management systems used around the world. An accurate, authoritative, registry of basic information on musical works, sound recordings and music videos is a fundamental, essential public good that supports a healthy framework for digital music licensing."

In Canada, a large group of publishers, rights societies, music providers and others are involved in a project known as the Global Repertoire Database (GRD), launched in October 2011[9]. A study was undertaken and the results shared in March 2012. The group's website documentation explains its mission. "There is a broad recognition across the stakeholder community of the urgent need to ensure that the global repertoire of musical works and rights is efficiently administered in the context of emerging multi-territory licensing solutions for the new online services, including those that have just started to emerge... Such a resource would maximize stakeholder trust in licensing solutions, deliver administrative efficiency through standardization and interoperability and provide for a level of accuracy, comprehensiveness and automation fit for the 21st Century."

Although different groups are advocating slightly different rules and frameworks for royalty collections, the acknowledgement and need for a central database seems

universal. Jim Griffin, for example, reports that rights holder information became the biggest challenge in his music rights experiment at colleges. "The real issue was aggregating all the rights holders," he admits. "It's a large problem in terms of insuring that you have the licenses and that the money ends up going where it needs to go. We couldn't even find half of them, there's no registry," Griffin says. "And that's what I'm spending all my time on now is registries."

Ian Rogers (Topspin, Beats, Apple Music) wrote about the need for a central machine-readable database on his personal blog, www.fistfulayen.com in November 2011[10]. Rogers called for, "A content registry where copyright holders can express the rules governing the use of their content; and a legislative requirement [that] sites dealing in media respect the rules expressed by the rights-holder in the registry."

Centralized copyright data is becoming almost a universally recognized goal, but it remains far from a reality. Creating a U.S. rights database for use by all royalty collection organizations would be a groundbreaking achievement. StreamCollect could provide the common ground to build a U.S. rights database by combining all the data from all its distribution partners. Each partner would have a seat on a special StreamCollect Board focused on the operation and development of this new centralized machine-readable information source. The partners would also enjoy unfettered total access to the data. Implementation of this board and database could happen in a second phase of the transition to this new system. At the start each partner would use its existing information for distribution purposes. Once built, a centralized d-base for U.S. rights holders would increase revenues for copyright owners, decrease expenses and be the envy of the IP world.

The Blanket Must Cover All Songs
In addition to the centralized list, it is equally important that all songs participate in a blanket license for streaming. Ian Rogers' brief, but sobering look at how the current system of licenses inhibits and restricts innovation tells the story. "To start a music service, you start by visiting the major labels," he says in his blog entry. "They ask for an advance payment (a steep barrier for most any startup technology company which immediately whittles the field down to relatively few players). [Next] you need to cut a deal with thousands of independent labels to build a catalog of music. No wonder piracy reigns supreme. Building a successful consumer-facing business on content is a

nearly insurmountable challenge. Few, if any, technology companies have historically made it to positive cash-flow on this model in the past 15 years."

Digital media expert Bill Rosenblatt who edits the blog *Copyright and Technology* correctly points out that to be effective, a blanket license has to be mandatory. He wrote on 10/10/11[11], "While SoundExchange has shown that automated, data-driven royalty compensation can be done, advocates of blanket licensing have run into a major snag: if you're going to offer an online music service a blanket music license you have to offer it for 'all music,' not just some of it, otherwise what you're offering is not going to be very helpful to the online music service."

The need for a blanket license is clear. When special cases or restraints are built around each recording it is especially frustrating to consumers who might then be motivated to circumvent the restrictions. The past decade has shown that asking consumers to respect a complicated group of rights is likely to bring disappointment to rights holders. A blanket license for streaming that includes all released music is the best way to make this plan work effectively.

Rosenblatt expresses agreement that a blanket license and an ISP fee are exactly what's needed, but doubts it will happen. "The problem is that offering a license to 'all music' is just plain impossible," he says. "At least without an act of Congress like that which produced SoundExchange." Is he correct about needing government intervention for a blanket license and a streaming ISP fee? Perhaps. But industry wide cooperation could be achieved through marketplace decisions.

For example, BMI, ASCAP and SESAC all currently offer blanket licenses to terrestrial radio stations. Couldn't a blanket license also be extended to cover digital streaming if the expanded license was connected to a plan that gave copyright owners confidence it was in their best interest? And it is entirely possible that ISPs might agree to collect a copyright fee in return for a profitable admin percentage and safe harbor status. If the license and fees were successfully negotiated without government intervention, then Rosenblatt's fundamental concerns could be successfully addressed. Alternatively, while the task of getting Congress on board is not to be underestimated, the odds of passage would rise considerably if all parties stood united and said, "Yes, a blanket license and an ISP fee is what we need."

9. FOCUS ON THE VISION

Let's reflect on the basic values and goals promoted by *The Digital Solution* and *Pay On the Way Into The Store* concepts.

The last decade has taken a toll on the relationship between record labels and consumers. The first fissure was caused by the birth of Napster and the MP3 file format. Suddenly, what had been a cordial seller/consumer relationship was recast into a "them against us" mentality. Understandably, illegal file sharing inflamed the labels. They responded sharply with DRM and lawsuits aimed against large companies, individuals and even college kids, but the highly publicized lawsuits ignited negative public opinion. Positions hardened on all sides. Labels suggested that consumers needed to be re-educated about the woes of theft. Fans characterized labels as greedy.

Labels were also at war with the technology community who they blamed for "getting rich on the backs of music creators and causing this whole mess." Each new technological idea was viewed as a possible threat which might further undermine the increasingly delicate balance of the music industry's business model. This suspicious attitude toward technology has formed an industry culture that fights against innovation and tries to inhibit change. Long term it has been bad for business.

Back On The Same Team

Employing the ISP as a tollbooth insures that intellectual property owners get compensated regardless of how new technology finds ways for consumers to share and/or discover new music. Just like our movie theatre or football game example earlier in this book, if you're in a seat you've already paid the fee. With compensation for creators assured, innovation can be applauded and new ideas evaluated on the basis of merit.

Most importantly, the label, artist and consumer can join hands and again be part of the same team with mutual respect. Under the *Pay On The Way Into The Store* plan these relationships can be healed.

Scale Is Crucial

What makes *The Digital Solution* different than current subscription offerings from Pandora, Spotify, rdio, Beats and Rhapsody, for example? Answer: its enormous scale. Comparing today's paid subscriber numbers—under 10 million—with 192 million smartphone users for example illustrates why the *Digital Solution* scale is so crucial. The existing business model will not generate enough revenue without either growing exponentially and/or substantially raising rates. Involving *all* Internet users however, builds a reasonable royalty revenue base while at the same time keeping the fee-per-person affordable.

10. IMPLEMENTATION STRATEGY

A plan, is a plan. But ultimately it must be implemented. So in this chapter we examine how *The Digital Solution* could become reality, plus weigh some of the difficulties by making a "best guess" to see which of the various stakeholders might support it.

There are two basic pathways that could lead to enactment of the plan—a congressional mandate requiring the ISPs to collect a consumer fee or private marketplace negotiations. Let's study these concepts further.

Government Intervention
In a perfect world a government mandate would be the most direct way to get results, but in view of today's contested legislative climate, that route may be extremely difficult.

Congress finds it easiest to pass new legislation when everyone involved seems to support a single plan. Therefore, getting as many of the involved players on board with *The Digital Solution* would be of paramount importance. Stakeholder groups include publishers and songwriters; artists, musicians and record labels; the ISPs; online music companies like Spotify, rdio, and Pandora; plus the consumers who will be paying a small fee each month and getting access to the music.

Building mutual agreement will take time and leadership. Supporters of the plan will need to voice their opinion, stimulate dialog and help educate others. Congress wouldn't

need to legislate every last detail of the plan. The enactment of a mandatory ISP consumer fee, the StreamCollect Fund, the statutory or blanket license and a unified digital royalty would provide most of the necessary framework. Coordinating the distribution entities and a Board of Directors to oversee the newly-created centralized master contact list would complete the process. Distribution percentages could be negotiated under the supervision of a Government-appointed mediator. Congressional support and the legal mandate it provides would be ideal, immediately giving the plan the scale it needs top succeed.

Unfortunately, getting the government involved may be so complex as to be virtually unattainable. Fortunately, there is another way...

Private Marketplace Negotiation

A solution could be effected without government intervention if the involved parties determined it was in everyone's best interests. The most critical step hinges upon the ISPs agreeing to collect consumer copyright fees and forward them to the StreamCollect pool.

Why would ISPs do this? One reason is they would receive a collection fee and gain safe harbor legal status. Negotiations would hinge upon the ISP administrative fee percentage and getting a majority of providers to take part. Parties on both sides would have to carefully crunch the numbers and decide how to make it work. ISP admin fees would be almost pure profit going straight to the bottom line.

ISPs may not be anxious to add new charges onto customer invoices. However, if most or all of the largest players participated, the fee would not be viewed as a competitive advantage or disadvantage. And, if marketed correctly it would also be a great new service for consumers, giving them access to music at greatly reduced rates.

Making the new fee optional is another consideration. For example, if only 50% of ISP customers opted to pay the monthly fee, the StreamCollect fund could still amount to more than $5 billion which would greatly improve the situation for all stakeholders. Making the fee "optional" is not ideal because the plan needs scale to really work effectively, but it would be a valuable start. And, if marketed correctly, a large number of consumers are likely to opt in when they understand the benefits. With *The Digital*

Solution framework built and its working parts in motion, participation and dollars collected would surely grow.

At first glance the ISPs appear to have an upper hand in the above negotiation, but that may not necessarily be true. Safe harbor status wipes away litigation concerns and adds balance. Music streaming companies might also help persuade the ISPs to cooperate. *The Digital Solution* benefits streaming companies by lowering their fees and creating a more realistic business model. For example, Spotify and Pandora claim they currently pay out over 70% and 60% of revenues respectively. The new plan would reduce that to a range of about 15%, similar to satellite radio. Perhaps most importantly, tech giants like Apple and Google would be able to innovate and introduce new ideas under a new statutory license. Support from these corporate giants would also likely add balance to the ISP discussions.

The Broader Base

The following list of stakeholder groups offers a "best guess" description of how they are likely to react to the *Digital Solution* plan. Organizations representing these groups such as RIAA, NMPA, NSAI, DiMa will likely hold positions similar to the groups they represent and therefore are not listed individually. Consumers as a group are also not listed below because their reactions have been discussed throughout the book and earlier in this chapter.

Likely To Favor The Plan
• Publishers, Songwriters, Artists, Musicians, Producers and Record Labels

These groups are all intellectual property owners that receive royalty payments. Once they are satisfied that *The Digital Solution* will reduce piracy, increase payments and make it easier for them to register their works with a one-stop contact database they will likely support the changes.

• Sound Exchange, BMI, SESAC, ASCAP, Harry Fox

These are the five royalty distribution entities outlined in the plan that will receive funds from the StreamCollect pool and forward them to the proper copyright owners, based upon usage. StreamCollect funding greatly increases the amount they currently distribute to copyright owners.

- **Spotify, Pandora, rdio, Slacker, Google**

Streaming music companies such as the ones listed here currently pay high royalty rates as a percentage of revenue, plus in the case of the on-demand streamers, deals have to be negotiated individually with each rights owner. The new system would institute a statutory license and royalty rates more in line what other media channels pay. These companies will embrace the new plan because it compensates rights holders fairly and supports innovation.

- **iTunes, Amazon**

These are the two largest players in the digital download market. The plan does not interfere with this segment of the music market in any way. However, download vendors will surely be analyzing how the plan might affect their present and future competitive positions, and in fact both of these giants have already launched streaming music options. More choice is always great for consumers.

- **Hardware Manufacturers**

New technology is one of the best ways to stimulate hardware sales. As previously explained, the plan embraces innovation and new technology. Hardware manufacturers will reap rewards in this new climate which warmly encourages the development of new ideas.

- **Satellite Radio**

Sat broadcasters compete with Internet streaming channels, even though the hardware they use is quite different. So in the short term, like terrestrial radio, Sirius/XM is likely to frown on seeing any kind of relief for streamers even though, the new streaming rates would be quite close to what the Sats pay. But, now that the Internet is reaching everywhere—including automobile dashboards—one has to wonder if SiriusXM will switch to cost-effective Internet distribution when its satellite batteries burn out. In that scenario, satellite radio will become a strong supporter.

Undecided
- **Traditional Retail Music Sales Outlets**

The "access" model for music, is in direct competition with buying physical CDs. The transition from one format to the next will be a slow process, but bricks and mortar merchants are unlikely to favor any plan which might speed the usage and adoption of streaming. On the other hand, retailers are also opening virtual storefronts. It's not

unlikely that the new rules could birth a profitable new online retail model using streaming.

• ISPs—Broadband and Mobile

Winning this group's support is critical to the plan's success. It will require open discussions about the long term legal and economic benefits they will accrue. It is also going to take some determined negotiating on behalf of rights holders who also stand to gain much. Ultimately, ISPs move from undecided to "In favor."

Likely To Be Against The Plan
• Terrestrial Radio

As the audience war continues, terrestrial and Internet channels will continue to compete for market share. Currently, terrestrial radio enjoys licensing advantages as compared with rates streaming companies pay. As a result, radio is unlikely to cheer as streaming companies are granted a better deal, even though the new deal would be mostly identical to what the tower stations are paying. Terrestrial radio may be the only player not pleased to see the Internet streaming business placed on a more secure and robust platform, especially if the changes weaken their current streaming competitive advantage.

11. IT'S NOT ABOUT RECORD LABELS

TechCrunch.com founder J. Michael Arrington voiced a strong opinion against variations of what he calls a "music tax" in a series of 2008 articles published in his technology blog. With article titles such as "The Music Industry's Last Stand Will Be A Music Tax,"[12] and "The Music Industry's New Extortion Scheme,"[13] it's easy to discern his attitude. "The music industry is going to make one last stand to preserve their 'bloated bureaucracies,'" says Arrington. "And that is going to be a call for a music tax to create guaranteed revenues." Before addressing his specific concerns it's important to note that this plan is not about record labels, it is about compensating copyright owners —the publishers, songwriters, artists, musicians and more whose shrinking ranks represent anything but "bloated bureaucracies."

Arrington prefaces his complaints with an economic analysis which concludes, "the price of music will have to fall towards free." He backs this assertion by citing that digital property rights have become mostly unenforceable because file sharing is so easy. Essentially he is agreeing with the discussion earlier in this book about the relationship between supply, demand, scarcity and price. Over four years have passed since Arrington's articles on this subject and as he (and many others) envisioned, music prices have fallen, both at retail and online. Physical albums which routinely priced at $15 or more in 2008 are now available for $10 and less. Today, frontline digital albums can sometimes be found on sale for as low as 99¢, $2.99 and $3.99.

Let's address Arrington's concerns as expressed in his article written Jan. 10, 2008.

"Forcing people to buy music whether they want to or not is not a solution to this problem. The incentives created by such a system are perverse—guaranteed revenue and guaranteed profits will remove any incentive to innovate and serve niche markets. It will be the death of music.

Music industry revenues will be a set size, regardless of the quality or type of music they release. Incentives to innovate will evaporate. There will only be competition for market share, with no attempt to build the size of market or serve less-popular niches."

Arrington makes no mention of any plan for the distribution of the collected revenue which may be why his vision differs so greatly from the plan outlined in this book. For example, ASCAP, BMI and SESAC have been collecting a guaranteed revenue pool from terrestrial radio stations for decades. Has that made songwriters and publishers lazy? Has it "removed any incentive to innovate and serve niche markets," as Arrington fears?

The result has actually been the opposite. Why? Because the funds are distributed according to usage, not just for showing up in line. The most popular music gets a higher percentage of the royalty pool and less-played tracks get considerably less. Performing rights payouts are carefully monitored by genre as well which insures that niche markets also get compensated in proportion to their use.

Under the new plan, small niche markets and music far out on the long tail will still face the same challenges they have today in terms of performance/sales revenue streams. However, the plan encourages consumers to discover new and niche music. All music is included, under the monthly fee, meaning there is no added expense or economic risk to trying something new. This discovery effect should actually bolster the niche markets.

In the case of Pay On The Way Into The Store, the size of the royalty pool is based upon the number of ISP subscribers. But the size of the total pool has no bearing on the competitive landscape and while labels are included among the list of compensated intellectual property owners, they aren't singled out for special treatment. In fact, under the ISP-fee scenario it becomes easier for artists to self-release music and track payments. The entire process is greatly simplified. What is unchanged is the need to fight for consumer attention. To succeed financially, labels and/or individual artists will

still need to compete for mainstream attention based upon the quality and diversity of their music.

Let's examine Arrington's closing argument, "Asking the government to prop up a dying industry is always (always) a bad idea."

Is music a dying industry? Surely not. According to the 2012 IFPI Digital Music Report[14] (International Federation of the Phonographic Industry), music is being enjoyed through more channels than ever before including, downloads, internet radio, access subscriptions, bundling and cloud systems. But profitability remains elusive for most players as they grapple with the complicated task of achieving scale in a fragmented digital environment. IFPI Chief Executive Frances Moore concludes in the report that sustainable jobs and growth, "Cannot be done through innovation and licensing alone. We need a fair legal environment, effective cooperation from intermediaries and a resolute commitment from governments to use legislation to curb all forms of piracy. These are the priorities we will be pushing for in 2012."

IFPI Chairman Placido Domingo adds, "It is fundamental that artists and creators, and the producers that invest in them, should be rewarded for their work in the digital environment just as in the physical world. Governments and legislation have an essential role to play. A world where copyright is properly respected brings income to artists and producers and investment in artists of all genres. It also delivers jobs, growth and tax revenues. And, of course, it also brings an enormous amount of pleasure to billions of people."

The music industry is not just about propping up "unworthy" record labels as Arrington's ambush implies. Pay On The Way Into The Store is designed to sustain creators and intellectual property owners such as songwriters, musicians, artists, producers, publishers and others whose creative contributions continue to enrich our society and culture. If, as Arrington concludes, the plan was a windfall for labels, then why (four years later) have they not even begun to ask for it?

12. FAQS

This chapter presents a list of questions with brief answers to some of the most asked *Digital Solution* concerns.

1.) I don't listen to music why should I pay a copyright fee to my ISP?
A.) Our world would be a different place without the songs and singers that inspire us so often in our daily lives. Intellectual property and its creators contribute to the cultural and spiritual growth of our society. Pay On The Way Into The Store ensures that the exchange between creators and users in the digital environment is balanced and fair and therefore is most assuredly in the public's best interest.

2.) What about using a bandwidth meter to determine each person's fair share?
A.) It's possible that some kind of metering approach would more equitably balance consumer use and cost in the same way that utilities like water and electricity are billed. However, the scale of the plan, achieved by including all Internet users, is what makes it so effective and keeps individual rates extremely low.

3.) How is the money collected?
A.) Collections come from two sources—consumers with mobile and broadband Internet accounts plus online companies that stream music. Internet Service Providers will collect the fees monthly from consumers. StreamCollect will license and administrate collections from the companies streaming music online.

4.) Why will the ISPs agree to collect this money? What's in it for them?

A.) ISPs already send customer invoices, so collecting this copyright fee only requires the addition of a line item on their regular billing. In return for collecting the funds, ISPs will deduct an administrative fee to offset their expenses. ISPs and streaming companies that pay into StreamCollect will also receive safe harbor status or a statutory license that protects them from music copyright litigation.

5.) How is the money distributed?

A.) StreamCollect will be divided on a percentage basis between the various rights holder groups such as songwriter/publishers and/or label/artists and then distributed according to usage on a per song basis by rights organizations such as ASCAP, BMI, SESAC, Harry Fox and Sound Exchange. All royalty contact and rights information will be maintained and stored in one central database.

6.) Who will control the central contact database which will house the copyright information necessary to administrate royalties?

A.) The database will be machine-readable and accessible by all the rights organizations participating in the process. Each organization will have a seat on a specially created Board of Directors charged with the task of overseeing and administrating the central database.

7.) What is the advantage of having a unified digital streaming royalty? What's wrong with carrying over performance and mechanical designations to streaming?

A.) Having performance and mechanical royalties works nicely in the analog world, but is not a good fit for streaming. For example, is a stream a performance, a mechanical or both? Even professionals are still not in agreement over this question. A unified royalty simplifies the process and still can be divided fairly amongst *all* rights holders.

8.) Will the monthly consumer fee charged by the ISPs ever increase?

A.) The number of ISP subscribers is continuing to grow which would increase consumer collection totals without raising rates. Also the new system should stimulate the creation and success of new streaming businesses thereby increasing collections from that area as well. Years from now, when those numbers stabilize, it might be necessary to include cost of living fee increases.

9.) Could Pay On The Way Into The Store work for other kinds of intellectual property such as movies or books?

A.) At this time it's the music industry that has proved most vulnerable to the new properties of the Internet. However, the *Pay On The Way Into The Store* model could easily work for various kinds of intellectual property. If movies, books and/or publications were added for example, those industries would need their own rights administrators and special rules to optimize the process. Consumers would gain additional rights benefits but also pay additional fees.

10.) Is the plan fair for new and established artists?

A.) Every artist that has registered a work in the central database should receive some payment if their music is streamed. Those songs receiving the most play (streams) will get the highest payments. New artists will be able to immediately get larger payments as their music becomes more popular.

11.) Will the plan affect administrative costs for ASCAP, BMI, SESAC, Sound Exchange and HFA?

A.) The largest expense will be to administrate the central database and music company licensing/collections. However, distribution companies—ASCAP, BMI, SESAC, Harry Fox and Sound Exchange—will no longer have to deal with collections resulting in substantial cost/expense benefits. They will receive their share of collected funds directly from StreamCollect. This should also allow them to more actively service their member needs.

13.) Can this solution be implemented?

A.) To make the plan reality will first require industry consensus among the various stakeholders. Hopefully, this book will help speed the adoption of the idea, but individuals will also need to spread the word. Once there is general agreement, the changes could be implemented either with government support or via a marketplace decision.

ABOUT THE AUTHOR

Born and raised in Boston, MA., **David M. Ross** graduated from the University of Pennsylvania Wharton School with a B.S. in Economics and later attended the Berklee College of Music, majoring in arranging.

After spending ten years on the road as a professional musician, Ross traveled to Nashville and in April 1981 founded *MusicRow* magazine which he sold in 2008 after a successful 30-year reign as Publisher/CEO. During his time at *MusicRow* he pioneered and refined many of the email/social media marketing techniques revealed in his first book, *Secrets Of The List*.

One of country music's most-read industry analysts, Ross' continues to cover the intersection between Nashville's entertainment business and technology on www.Nekst.biz a blog about *"Music And The Technology It Powers."*

Currently Ross serves on the Board of Directors of The Country Music Hall of Fame and Museum and the Country Music Association. He received the CMA President's Award for Outstanding Service in 1998 and the Canadian Country Music Association's prestigious Leonard T. Rambeau Award for International Achievement in 2003. (dross@BossRoss.com)

Footnotes

1 @MusicRow, The Friday Sheet; January 10, 2003; #153. Call To Arms: A Digital Manifesto, Open Letter To Rolf Schmidt-Holtz, Doug Morris, Thomas Mottola, Alain Levy and Roger Ames. by David M. Ross. ©2003 MusicRow

2 http://www.digitalmusicnews.com/permalink/2012/120619lowery#ef_R5PXl0Yr2uwbEmoSyig; June 19, 2012.

3 RIAA 2011 Year-End Shipments; http://76.74.24.142/FA8A2072-6BF8-D44D-B9C8-CE5F55BBC050.pdf

4 http://cyber.law.harvard.edu/sites/cyber.law.harvard.edu/files/PTKChapter6.pdf

5 http://www.sctax.org/dor_help/Why+Do+We+Pay+Taxes.htm

6 http://cyber.law.harvard.edu/publications/2011/Rethinking_Music

7 https://www.mywerx.com/help/Aboutus.aspx

8 http://www.wipo.int/imr/en/

9 Global Repertoire Database Working Group. http://www.globalrepertoiredatabase.com

10 http://www.fistfulayen.com/blog/2012/01/a-proposal-for-legislation-to-proactively-combat-piracy-while-encouraging-an-open-and-innovative-internet/

11 http://copyrightandtechnology.com/2011/10/10/the-future-of-music-from-blanket-licensing-to-registries/.

12 Techcrunch.com, J. Michael Arrington, 1/10/08. http://techcrunch.com/2008/03/27/the-music-industrys-new-extortion-scheme/

13 Techcrunch.com, J. Michael Arrington, 3/27/08. http://techcrunch.com/2008/03/27/the-music-industrys-new-extortion-scheme/

14 IFPI Digital Music Report 2012; http://www.ifpi.org/content/library/DMR2012.pdf

www.ingramcontent.com/pod-product-compliance
Lightning Source LLC
Chambersburg PA
CBHW081903170526
45167CB00007B/3128